APERTURE MASTERS OF PHOTOGRAPHY

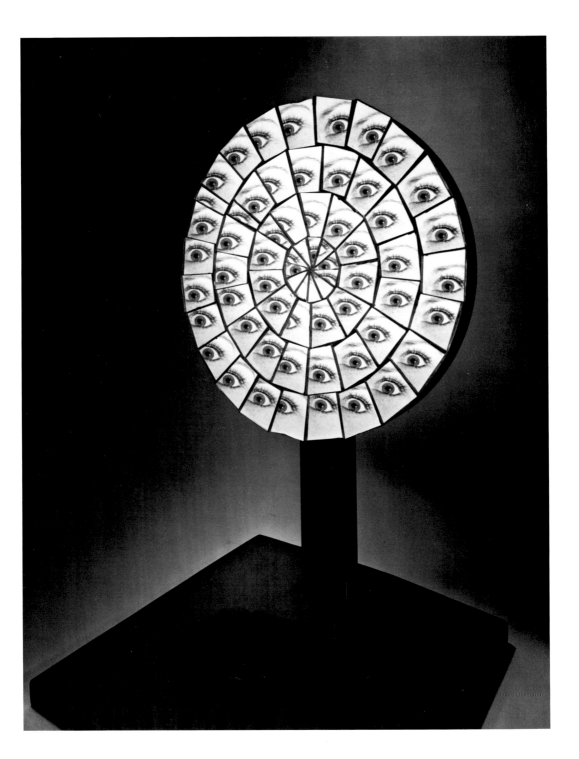

BERENICE ABBOTT

With an Essay by Julia Van Haaften

MASTERS OF PHOTOGRAPHY

APERTURE

Frontispiece: Parabolic Mirror, Cambridge, Massachusetts, 1959–61

Printed and bound in Hong Kong.
Library of Congress Catalog Number: 87-73572
ISBN: 0-89381-751-1

This 1997 edition is a coproduction of Könemann Verlags Gmbh
and Aperture Foundation, Inc.

Aperture Foundation publishes a periodical, books, and portfolios of fine photography to communicate with photographers and creative people everywhere. A complete catalog is available upon request. Address: 20 East 23rd Street, New York, New York 10010. Phone: (212) 598-4205. Fax: (212) 598-4015.

The Aperture Masters of Photography series is distributed in the following territories through Könemann Verlags Gmbh, Bonner Str. 126, D-50968 Köln. Phone: (0221) 93 70 39-0. Fax: (0221) 93 70 39-9: *Continental Europe, Israel, Australia, and the Pacific Rim.* The series is distributed in the following territories through Aperture: *Canada:* General Publishing, 30 Lesmill Road, Don Mills, Ontario, M3B 2T6. Fax: (416) 445-5991. *United Kingdom:* Robert Hale, Ltd., Clerkenwell House, 45-47 Clerkenwell Green, London EC1R OHT. Fax: 171-490-4958. *All other territories:* Aperture, 20 East 23rd Street, New York, New York 10010. Phone: (212) 505-5555. Fax: (212) 979-7759.

For international magazine subscription orders for the periodical *Aperture*, contact Aperture International Subscription Service, P.O. Box 14, Harold Hill, Romford, RM3 8EQ, England. Fax: 1-708-372-046. One year: £30.00. Price subject to change.

To subscribe to the periodical *Aperture* in the U.S.A. write Aperture, P.O. Box 3000, Denville, NJ 07834. Phone: 1-800-783-4903. One year $40.00.

K2 K4 K6 K8 K7 K5 K3 K1

Berenice Abbott was born on July 17, 1898 in Springfield, Ohio, the youngest of four children. Her parents divorced soon after her birth and she spent her early childhood separated from her older brothers and sister; she rarely saw her father. By the time she entered Ohio State University in Columbus at the age of nineteen with the idea of becoming a journalist, Berenice Abbott considered herself on her own.

Dissatisfied with her course of studies and perhaps impatient to get on with larger (if not yet definable) pursuits in her life, Abbott in 1918 accepted the invitation of a former classmate, Sue Jenkins, to visit New York. There she encountered the flourishing bohemian life of Greenwich Village where Jenkins and her husband-to-be, director Jimmy Light, were active in productions of the famed Provincetown Playhouse. Abbott did not return to college (except for one disappointing week at Columbia University, when she gave her journalism ambition one last try). For three years she supported herself at temporary jobs such as waitress and model, and appeared occasionally in productions of the theater. During this time she took up sculpture, outfitting a small studio apartment for the medium. She met Marcel Duchamp when he commissioned her to cast a chess set, and his friend Man Ray, both renowned Dadaists, among other artists and writers such as Djuna Barnes, Malcolm Cowley, and Sadikichi Hartmann who were to further her introduction to the sophisticated world of avant-garde art and ideas.

After the Great War, as World War I was called, Paris enjoyed a creative efflorescence that summoned writers, painters and other artists from the continent and America. Berenice Abbott set sail for France in early 1921, intent on partaking in what was to prove one of the most exciting, creative arenas of the century. Arriving in France with virtually no money nor prospects, and speaking little French, she again supported herself with odd jobs while studying sculpture. Discouraged by her lack of success, she left Paris for Berlin in 1923, only to find that her expectations as a sculptor remained unmet.

Upon returning to Paris she resumed her acquaintance with the circle of French artists and expatriate Americans who were her first friends there. In 1925, the year Abbott took up her new art, photography was beginning to enjoy an ascendency within a creative community devoted to modernism. Man Ray was supporting himself with a very fashionable and prosperous portrait studio for which he needed a new studio and darkroom assistant. Abbott challenged him to take her on when he declared that he wished to hire someone who knew nothing about photography. She took to the work instinctively, acquiring an adept technical

skill and developing her eye and judgment. In a natural and evolutionary way, Abbott began to take her own portrait photographs in Man Ray's studio. Abbott soon equaled and then rivaled her mentor, setting up an independent studio with the aid of friends, including art patroness Peggy Guggenheim, in 1926. Two years later, with André Kertész and Man Ray, among others, Abbott exhibited in the first Independent Salon of Photography to considerable critical acclaim.

The portraits she made during the 1920s comprise a catalog of the artistic and intellectual life of that time. Their straightforward artistry masks their great subtlety; Abbott permitted each personality she photographed to project outward to the viewer. Even in the studio, where a photographic artist has the most opportunity for manipulatory control, Abbott preferred realism to guide her style.

While pursuing her own work, Abbott embarked on a decades-long crusade to promote the work of the now celebrated Parisian photographer Eugène Atget, whose passion inspired her and whose work she acquired and then diligently organized after his death in 1927. Atget had begun photographing the streets, architectural details, and gardens of Paris and environs around 1899 after a career at sea and on the stage. He made thousands of carefully annotated images from which he produced prints for sale to artists, archives and museums. Like other Surrealists, Man Ray admired Atget's photographs and shared the few he had collected with Abbott while she was still his assistant. This glimpse of Atget's vision touched her deeply: though discouraged by Man Ray from doing so, Abbott later began to visit Atget at home, profoundly responsive to his singular dedication to expressing the poetry of everyday reality. Just days before he died, Abbott made the only extant portraits of the master photographer (Plate 17). In 1930, Abbott arranged for a volume of his photographs to be published in France and in America, and in 1964 published her own *The World of Atget,* in which she acknowledges Atget's influence on her as she extols his realism. Four years later, the entire Atget archive was purchased by the Museum of Modern Art in New York. Atget's example—his exhaustive inventory of old Paris, his uncompromising solitude, and his unwavering commitment to photography—was a source of motivation and even courage for Abbott throughout her struggle as a photographer of independent vision.

In 1929, Abbott returned to New York for a visit. Excited by the tempo of the rapidly transforming city that she had once called home, she settled her affairs in Paris and brought her portrait studio across the Atlantic. Just as it was Atget's ambition, at its most elementary, to document and preserve the vanishing Paris he loved, so Abbott was moved to record her city's transitory visage.

She began by using a small camera as a sketch pad, noting interesting locations, storefronts, facades, and views, all the while trying to get her portrait business underway. She reserved Wednes-

days for exploring the city, concentrating at first on Manhattan island, and later venturing into the outer boroughs, in particular the Bronx and Brooklyn. For her final photographs, she used an 8 x 10-inch view camera, her standard equipment for nearly the rest of her career.

Despite her sound reputation and critical success, the portrait studio upon which she expected to base her livelihood never gained firm financial ground. Abbott found it necessary to seek funds to pursue the New York City documentation project and approached sources such as the Guggenheim Foundation, the Museum of the City of New York, the New York Historical Society, and even private subscription. Titling her proposed project "Changing New York," Abbott declared that the camera alone could capture the "swift surfaces" of the city and argued that her position as a recently returned American expatriate gave her particular vantage from which to record the changing face of the metropolis.

Nevertheless, by 1933, in the midst of the Great Depression, Abbott's appeals for funding had all been rejected. Yet, continuing to work, Abbott gained considerable recognition and respect. Published as early as 1930, her New York City photographs began to be exhibited, first at the Museum of Modern Art, and in 1932 at the opening of the Museum of the City of New York. That museum in 1934 hosted Abbott's first solo exhibition, which led in turn to a life-long friendship with leading art critic Elizabeth McCausland.

Meanwhile, the depression had forced the government to include artists and related workers among the recipients for unemployment relief. While the majority of those involved in the Federal Art Project of the Works Progress Administration were interested in the traditional fine arts media and required photography only as a recording tool, the New York FAP office included a photography section. In 1935 Abbott applied to this organization to carry out "Changing New York." Her words best explain her motivation and now define her project's success:

> To photograph New York City means to seek to catch in the sensitive and delicate photographic emulsion the spirit of the metropolis, while remaining true to its essential fact, its hurrying tempo, its congested streets, the past jostling the present . . . The tempo of the metropolis is not of eternity, nor even time, but of the vanishing instant. Especially then has such a record a peculiarly documentary, as well as artistic, significance. All work that can salvage from oblivion the memorials of the metropolis will have value.

In New York's photography community, still engulfed by Alfred Stieglitz's dominating personality and influence, Abbott's appreciation of temporality and change found little favor. Likewise, Abbott surely felt the strained atmosphere of the art world could only drain the tremendous energy

required for her enterprising project. Instead, she found a most suitable champion of her work in I. N. Phelps Stokes, the noted collector of American historical prints and author of the monumental *Iconography of Manhattan Island*. Sitting on the boards of several civic and cultural institutions, he understood the dual artistic and documentary value of the work Abbott sought to complete and strongly supported her FAP application.

Twice during this early period of New York activity Abbott ventured outside the city. In 1933 the noted American architectural historian Henry Russell Hitchcock entrusted her to photograph two of his projects concerning pre–Civil War architecture and the buildings of Boston architect H.H. Richardson, which took her through the cities of the Atlantic seaboard. Two years later, with her friend Elizabeth McCausland, Abbott traveled to the deep south, circling first through Pennsylvania, Ohio, and on to St. Louis. While the resulting work gained additional, if limited, attention, both journeys served more to reinforce her sense of urgency about recording the most dynamic of all American locales, New York.

The fall of 1935 brought not only a commitment from the FAP that was to last for four years, enabling Abbott to hire a small staff and purchase equipment (including a used car), but also her debut as a teacher of photography at the New School for Social Research in New York, the beginning of a happy relationship that was to endure until 1958.

In the first two years that she devoted her full effort to "Changing New York" Abbott accomplished much, and in late 1937 produced a solo exhibition at the Museum of the City of New York. The following year publisher E.P. Dutton approached the FAP about a book of New York photographs, and in 1939 brought out *Changing New York,* which included ninety-seven of Abbott's meticulously captioned pictures and historical commentary by Elizabeth McCausland. (It was reprinted in 1973 as *New York in the Thirties*.)

By 1939 the FAP concluded the project and Abbott lost her staff, funding, and finally, her salary. For all practical purposes, she stopped photographing the city, except for new images she made in 1947–48 for *Greenwich Village Today and Yesterday* (1949) with text by Henry Wysham Lanier.

Fortunately, Abbott decided she could rely on her teaching position and the experience of her years in the classroom to write about the methods and philosophy of photography that were so central to her being. Her *Guide to Better Photography* (1941) is an eloquent and powerful document of the best photography of the period, providing great insight into an empathetic spirit that Abbott was able to liberate within herself: ". . . there is that deeper need for self-expression. In every human being, there are capacities for creative action. . . . This need of human beings is almost as deep-seated as their need for air to breathe and food to eat."

At the same time, Abbott stressed the validity

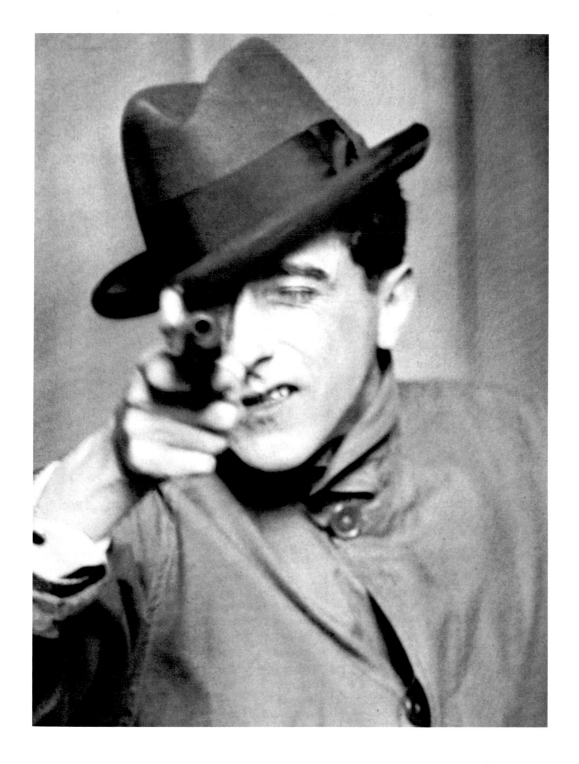

of realism as the vehicle for her expression, giving mature and well-considered voice to her enduring commitment to truth:

> As I see straight photography, it means using the medium as itself, not as painting or theater. . . . All subject matter is open to interpretation, [and] requires the imaginative and intelligent objectivity of the person behind the camera. The realization comes from selection, aiming, shooting, processing with the best technic possible to project your comment better. . . . [Yet] technic for technic's sake is like art for art's sake—a phrase of artistic isolationism, a creative escapism. . . . In short, the something done by photography is *communication*. For what our age needs is a broad, human art, as wide as the world of human knowledge and action; photography cannot explore too far or probe too deeply to meet this need.

Not only do these comments clearly reflect the tenor of the times—on the brink of the second great war of her generation and rebounding from the slowly expiring effects of the pictorialist movement in photography—they also suggest Abbott's major photographic preoccupation of the next two decades: presenting scientific principles and phenomena photographically.

Eager to find a new arena in which to exploit her talents and energy, Abbott turned to science as the phenomenon of the age most in need of

interpretation: "There is an essential unity between photography, science's child, and science, the parent. Yet so far the task of photographing scientific subjects and endowing them with popular appeal and scientific correctness has not been mastered. The function of the artist is needed here, as well as the function of the recorder." Employed by the short-lived *Science Illustrated* in the mid-1940s, she devoted years to seeking interest, and funding, all the while resourcefully devising her own equipment and techniques—garnering several patents—as required by the tasks of depiction she set for herself. She also continued to write, speak, teach, and participate fully in the intellectual life of the United States. Her *View Camera Made Simple* was published in 1948; *A New Guide to Better Photography* appeared in 1953.

By 1957, the year of Sputnik, the Physical Science Study Committee (composed of MIT scientists and high school science teachers) was hard at work on a new high school physics curriculum that would teach basic principles through experiments and eloquent explanations, both verbal and pictorial. Fortuitously, Abbott's work was well-known by the group's chairman, Dr. E. P. Little, who in 1958 hired her on the spot to provide or create the required illustrative photographs. The skeptics among the group were readily won over by Abbott's professionalism and clear understanding of the subjects' visual requirements.

Engineering her own setups and engaging the talents of her colleagues, Abbott made images that not only picture the phenomena under discussion

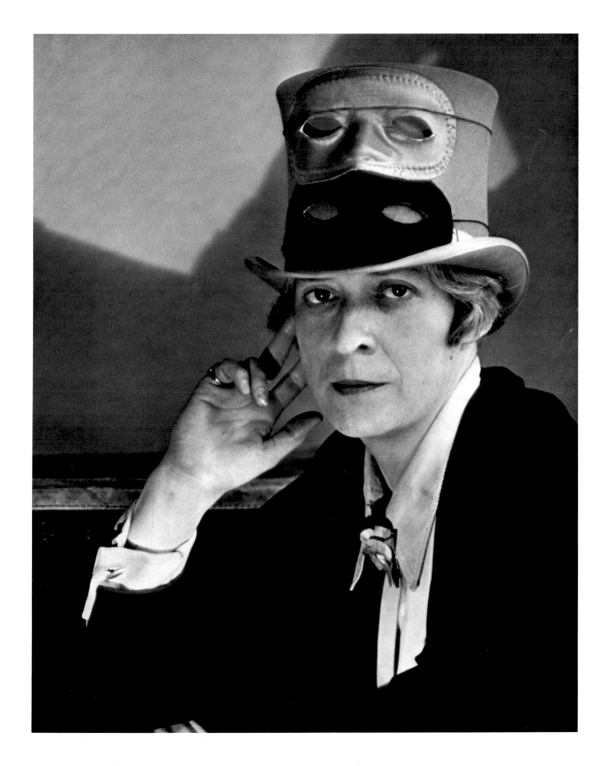

but also communicate with a photogenic realism peripheral information about the nature of light, the wave force, and magnetism. Well before the seminal textbook *Physics* appeared in 1960, Abbott's images garnered welcome attention and praise. An exhibition was held at the New School and articles appeared in the *New York Times Magazine* and *Art in America,* the latter quoting Abbott: "Surely scientific truth and natural phenomena are as good subjects for art as are man and his emotions, in their infinite variety." The photographs were widely exhibited in schools and science museums, often providing viewers with their first introduction to the world of fine photography. In the 1960s and 1970s Evans G. Valens utilized these photographs in several young peoples' books he put together.

With her work for the PSSC concluded in 1960, Abbott could devote attention again to the Atget archive and to other publishing projects begun earlier. But one important body of work has never been published: In 1954 Abbott twice traveled the length of U.S. 1, the pre-interstate highway linking Maine to Florida, to photograph the vanishing small-town life along the eastern seaboard. The images, with their particularities of subject and great subtlety of viewpoint and light, share with "Changing New York" an ability to function as both documents and art. In their unapologetic realism they provide a moving humanistic and aesthetic counterpoint to the harsher visions of the 1950s.

Once introduced to Maine, Abbott knew she wanted to live there, and in 1956 purchased a run-down roadside inn in Blanchard. Ten years later she moved to her new home for good from her Commerce Street studio in New York. In 1968, in addition to finally settling the disposition of the Atget archive, Abbott and writer Chenoweth Hall produced *A Portrait of Maine* containing Abbott's mostly smaller-format photographs made between 1954 and 1967.

In the 1970s and 1980s, Abbott attained critical standing and financial security, showing her work in several major exhibitions in New York, Washington, and abroad. She also received numerous honorary degrees and awards. A reflective and insightful biography by Hank O'Neal, *Berenice Abbott, American Photographer,* appeared in 1982 with extensive commentary on the photographs by Abbott herself. Beginning in 1974, eight portfolios of her photographs were issued, mostly by Parasol Press, and in the mid-1980s an organization called Commerce Graphics was created to manage her archive.

Abbott remained committed to realism and to the power of the photographic image that speaks for itself. The strength she evinced to pursue this vision led to her single-handed rescue of Atget's work and to remarkable technical innovations for the camera. Her legacy resides in six decades of masterful photographs.

Julia Van Haaften

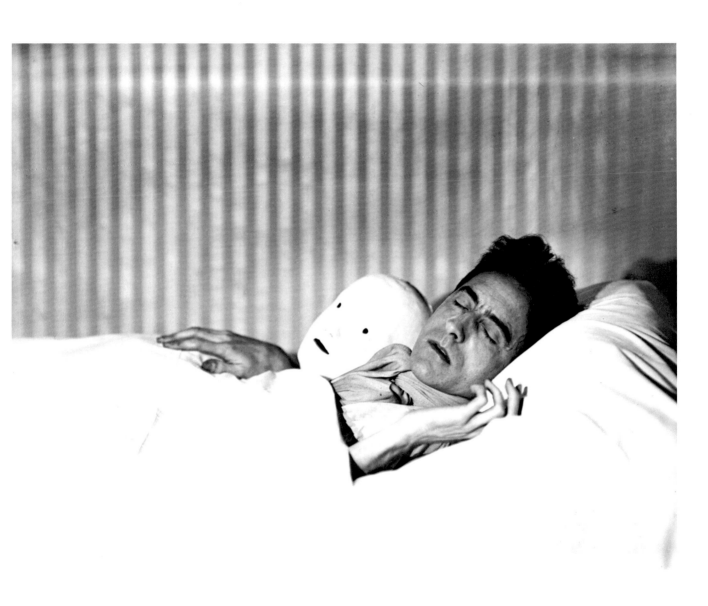

Nora Joyce, Paris, 1927

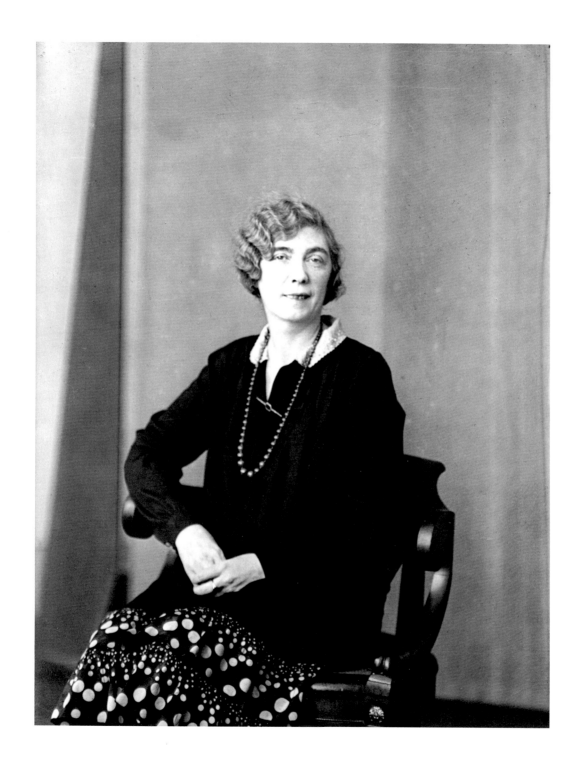

Eugène Atget, Paris, 1927

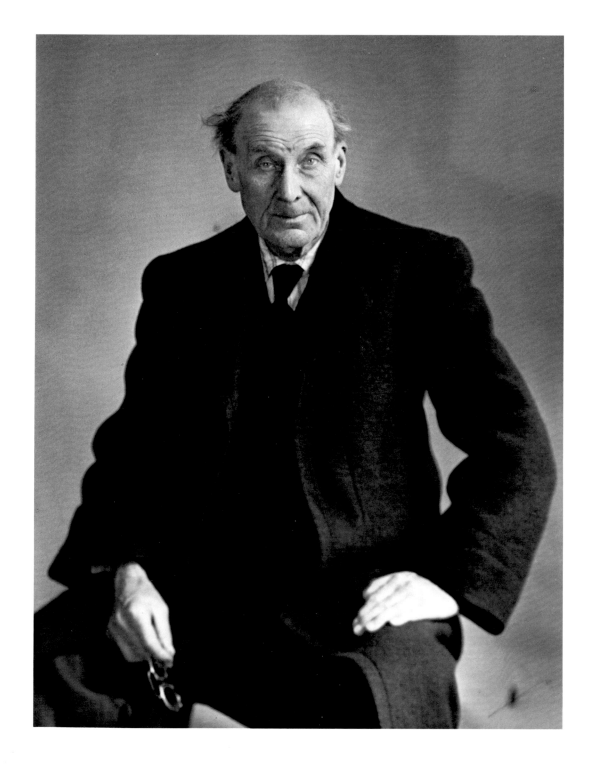

Red River logging project, California, August, 1943

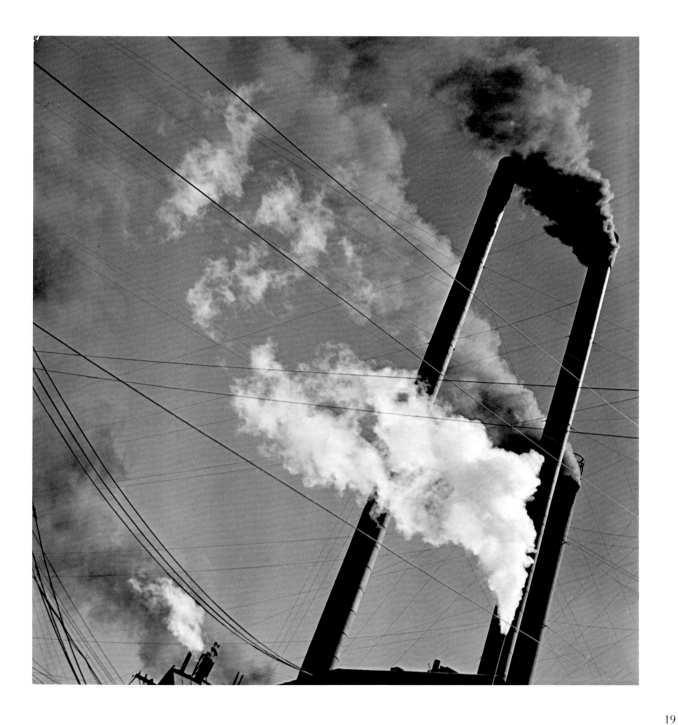

Triboro Bridge, East 125th Street approach, c. 1937

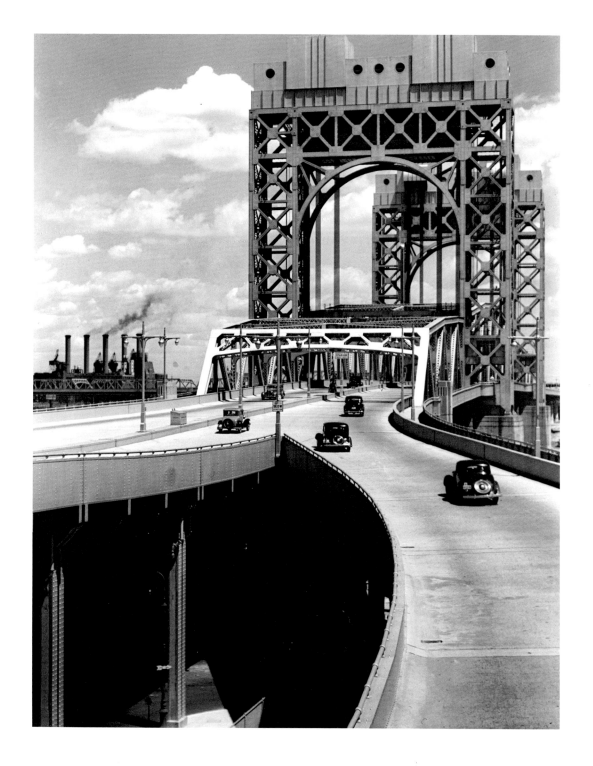

A.J. Corcoran water tanks, New Jersey, 1930

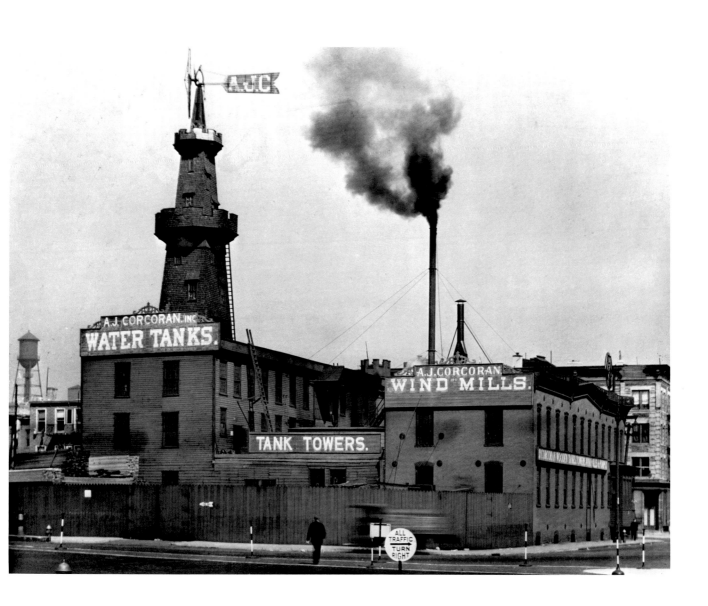

23

Hester Street, New York, c. 1929

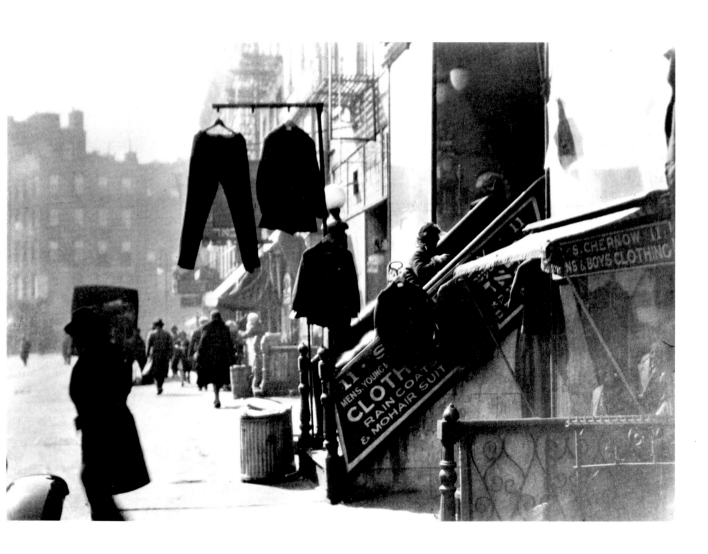

Repair shop, Christopher Street, c. 1949

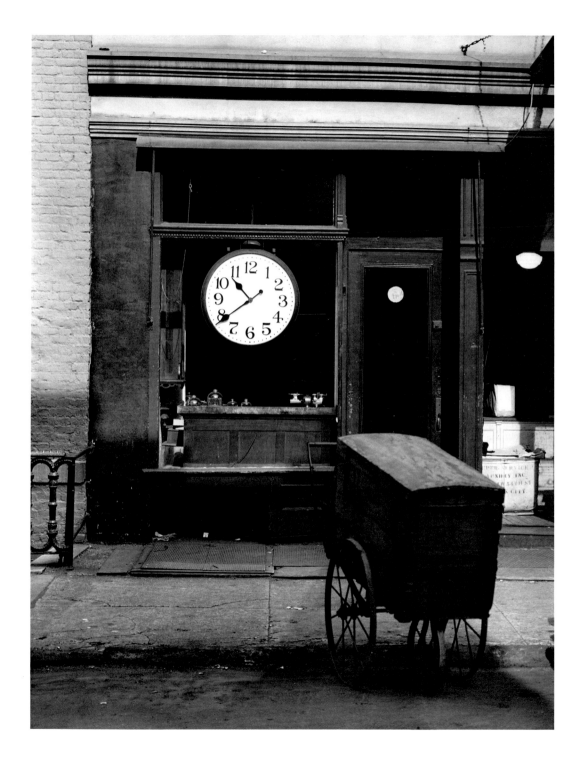

Pine and Henry Streets, March 6, 1936

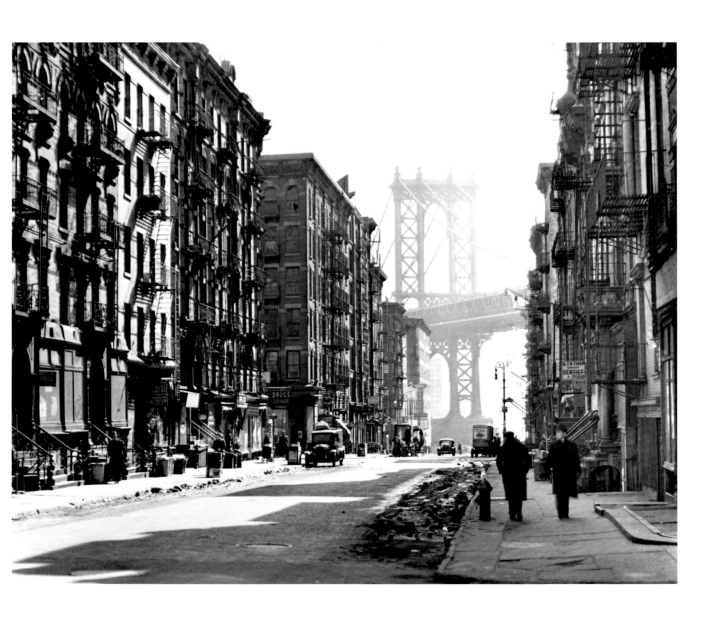

Cheese shop on West 8th Street, c. 1949

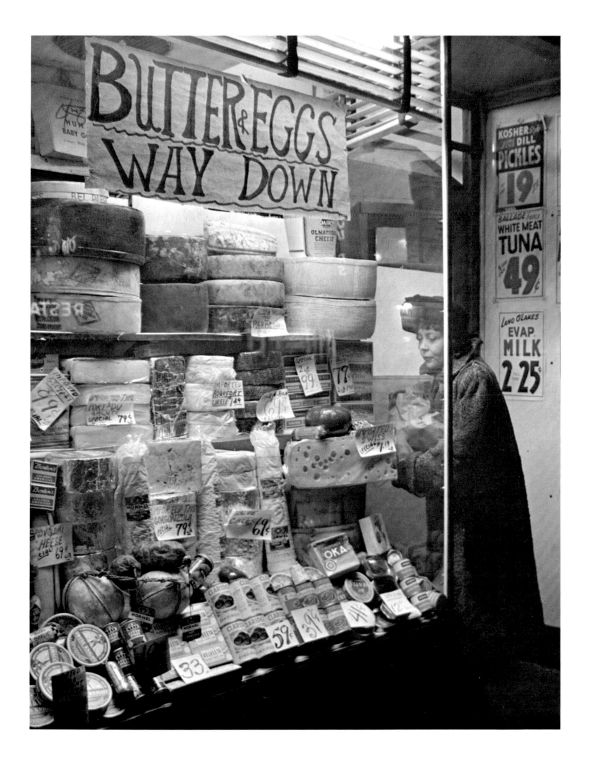

Trinidad dancer at the Calypso, Macdougal Street, c. 1949

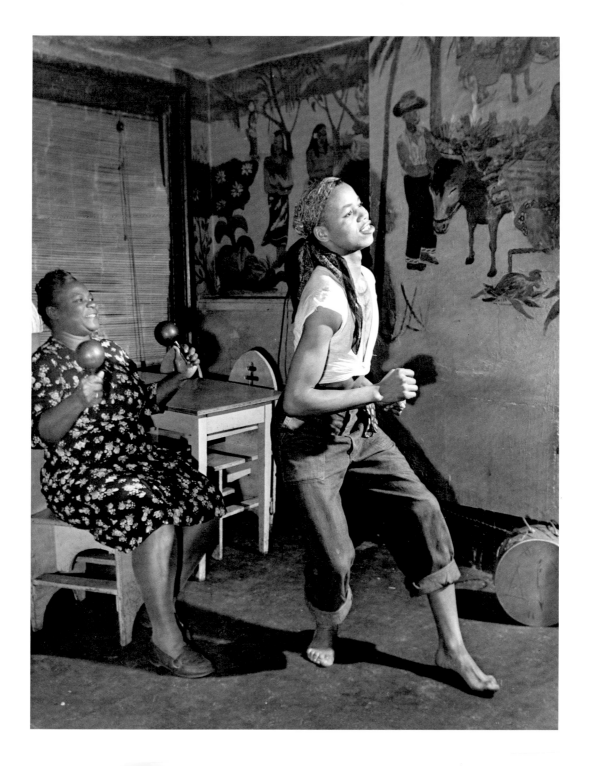

Broadway to the Battery, from the roof of Irving Trust
Company Building, One Wall Street, May 4, 1938

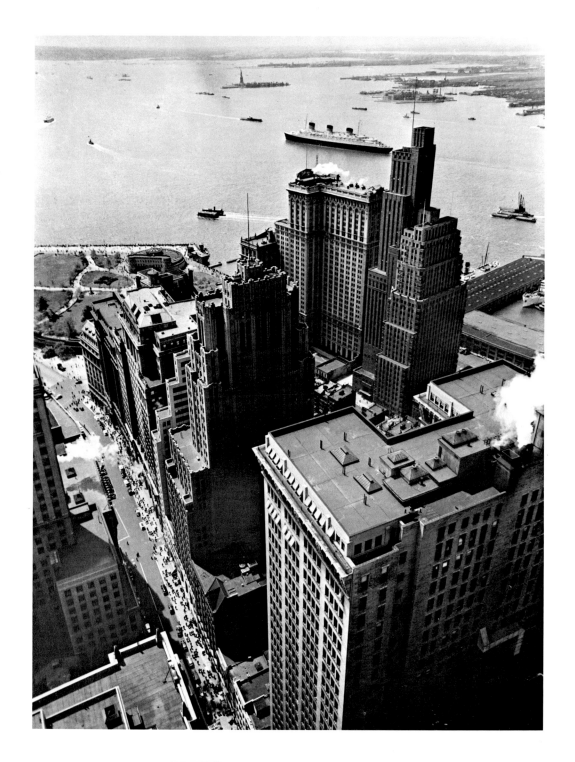

Designer's window, Bleecker Street, 1947

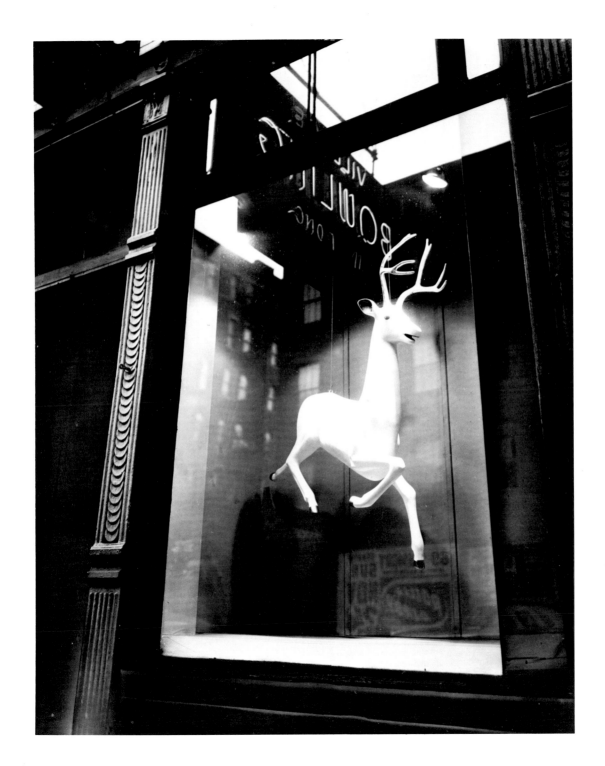

Union Square, Manhattan, 1936

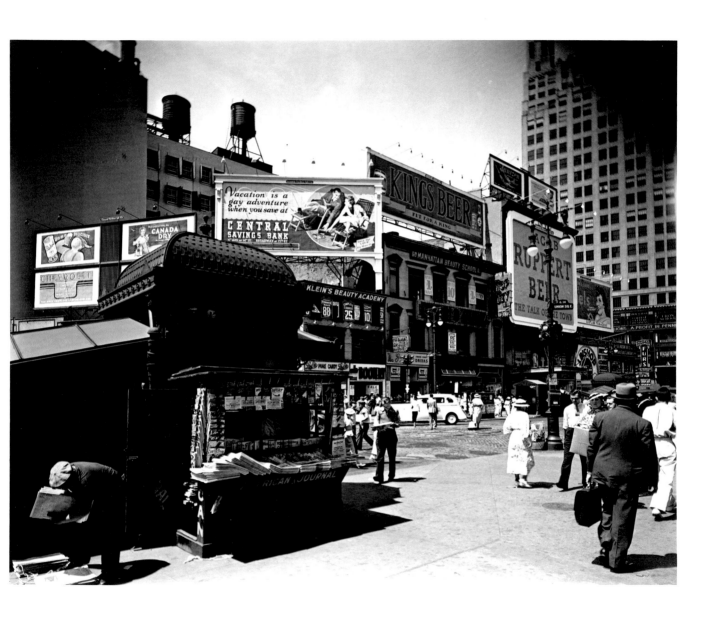

Trinity Church, New York, 1934

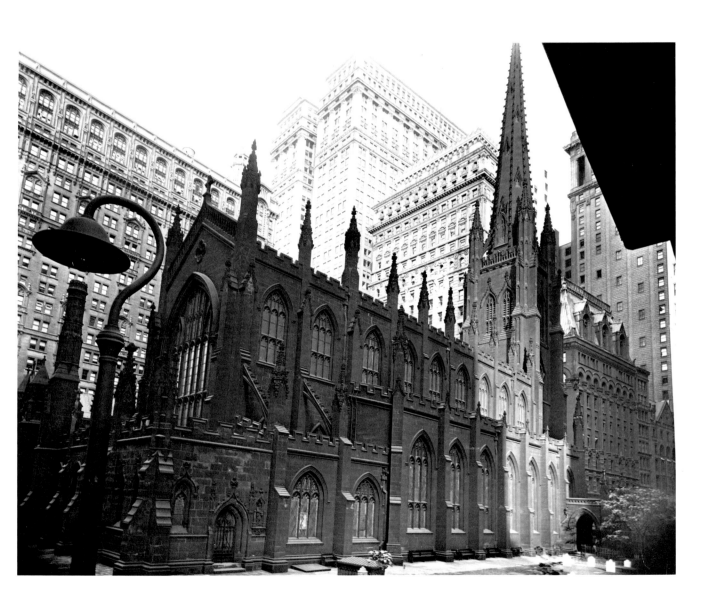

Statue along the tidal basin, Washington, D.C., 1954

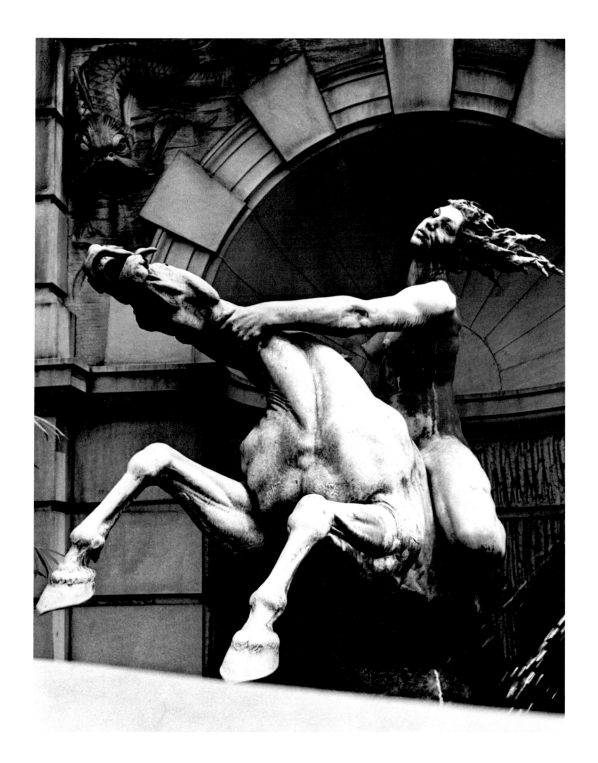

Exchange Place from Broadway, c. 1934

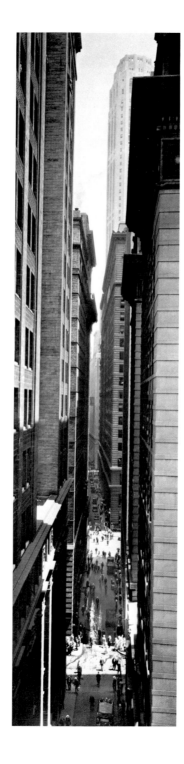

Manhattan Bridge, November 11, 1936

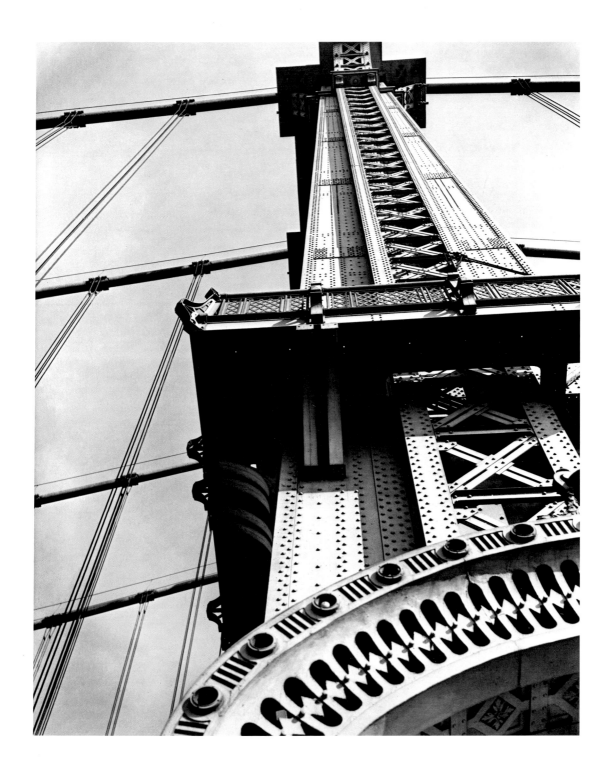

Flatiron Building, Broadway and Fifth Avenue, c. 1934

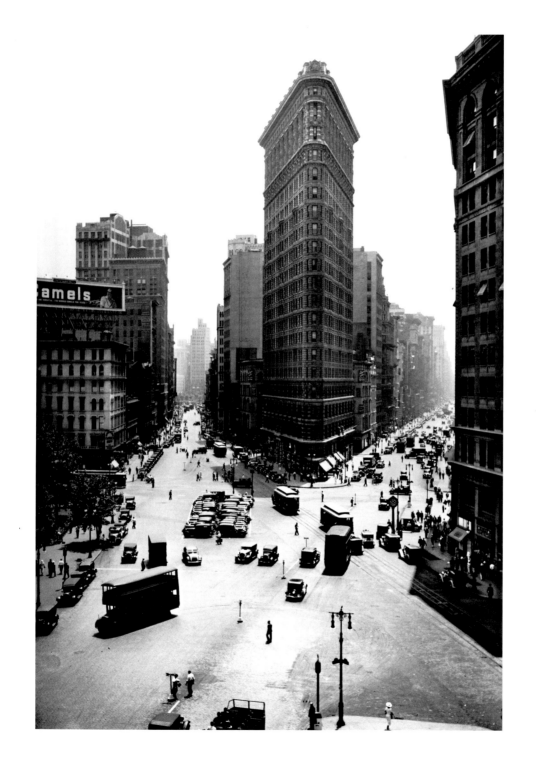

Tempo of the City, Fifth Avenue and 44th Street, 1938

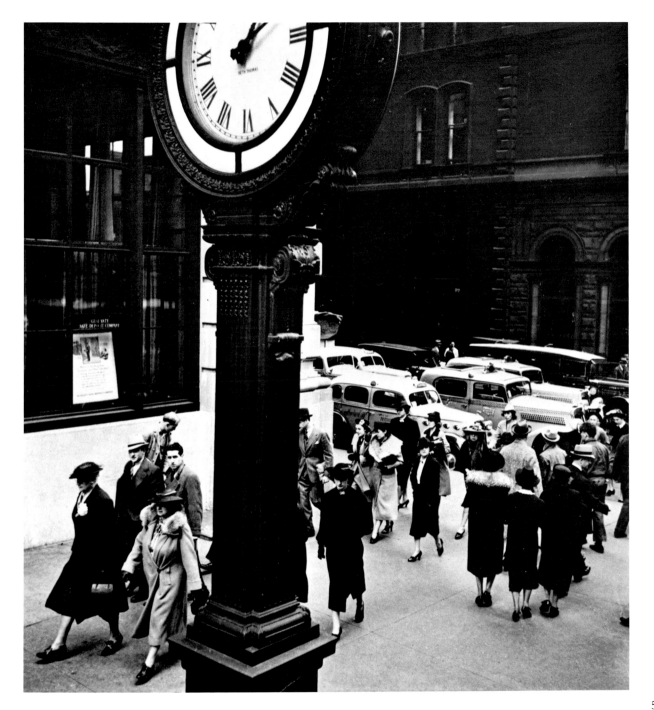

Fifth Avenue Coach Company, 1932

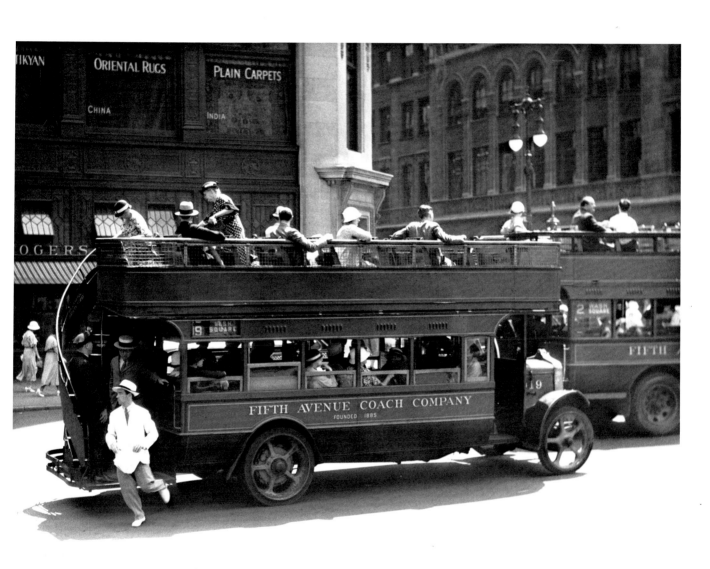

View, Lower Manhattan, 1956

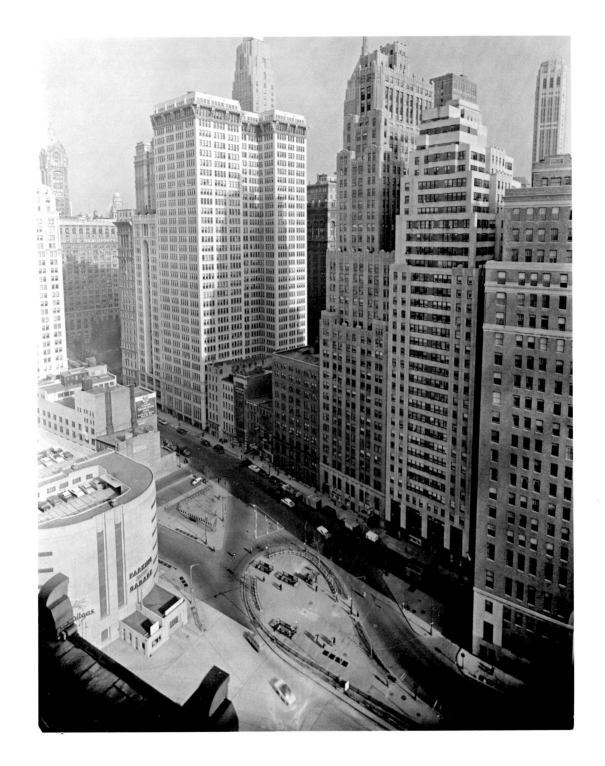

Nightview, New York, 1932

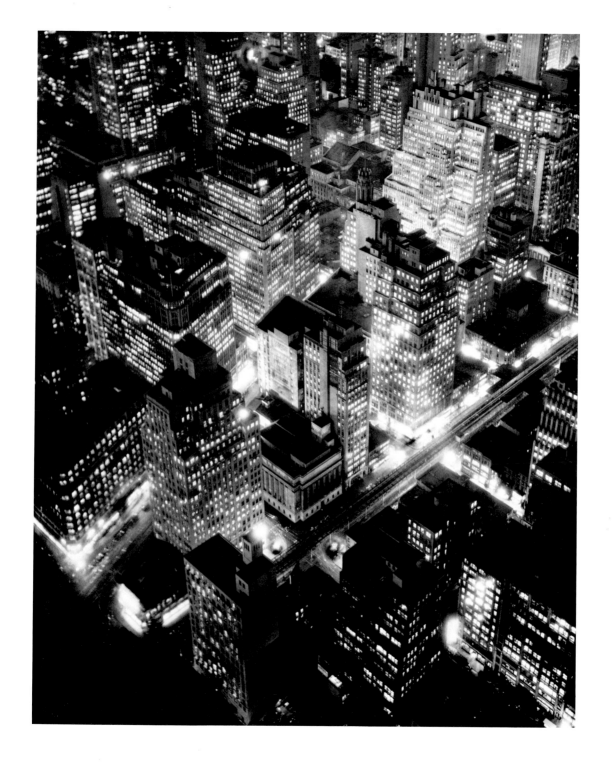

Van de Graff generator, MIT, Cambridge, Massachusetts, 1938

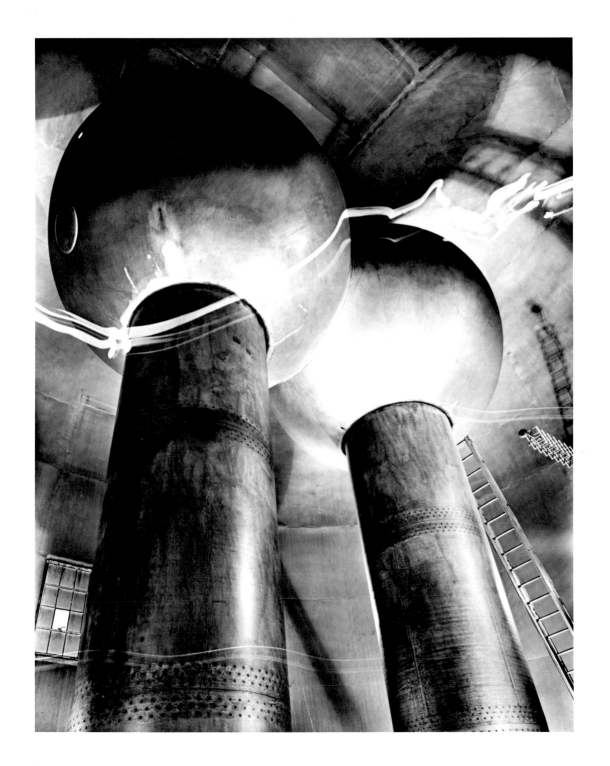

Interference pattern, New York, 1959-61

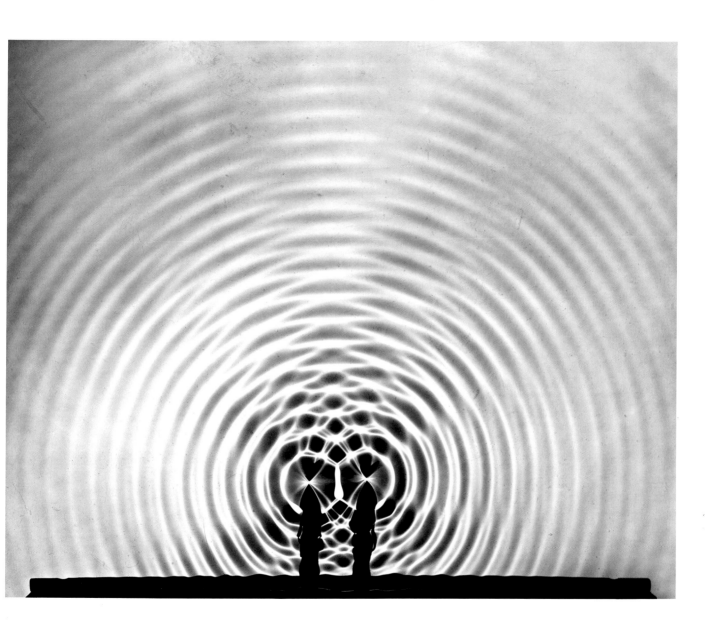

Multiple exposure of bouncing golf ball, New York, 1959-61

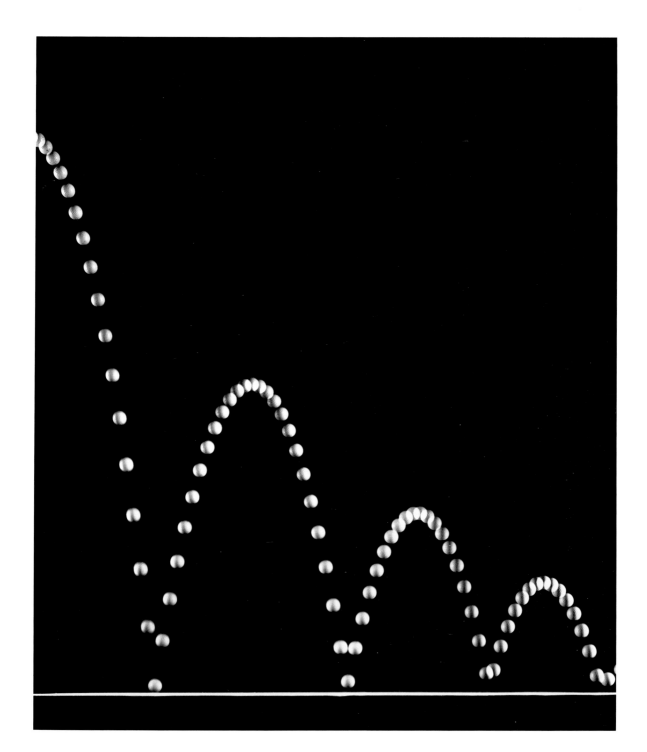

63

Focusing water waves, MIT, Cambridge, Massachusetts, 1958-61

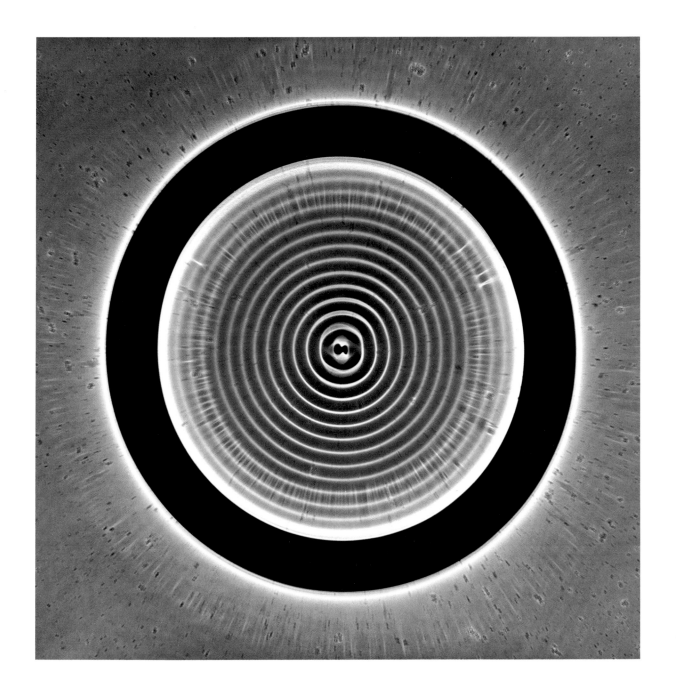

Patterns of the magnetic field, MIT, Cambridge, Massachusetts, 1958-61

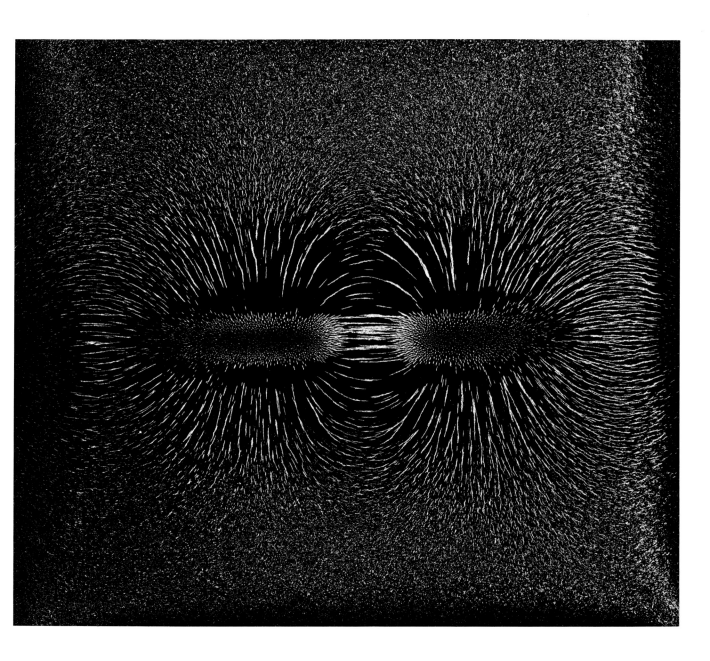

Penicillin mold, MIT, Cambridge Massachusetts, 1958-61

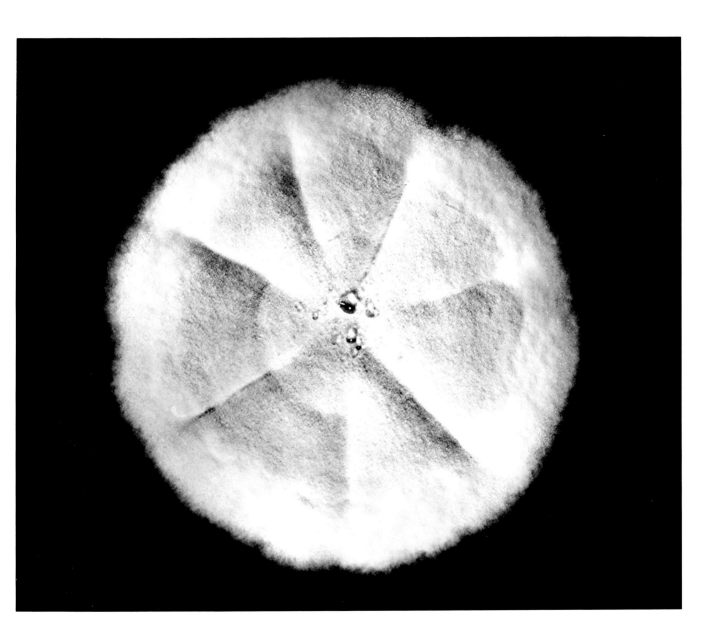

Light rays through prism, Cambridge, Massachusetts, 1958-61

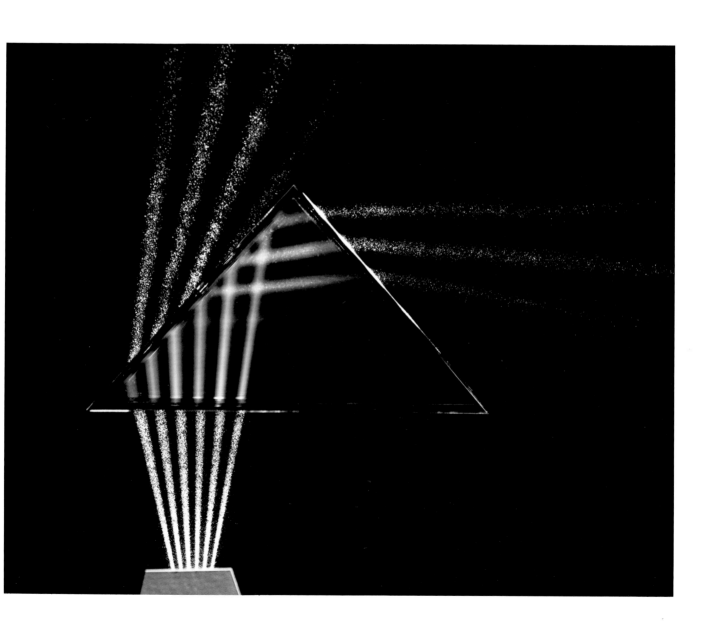

Amusement park, Daytona Beach, Florida, 1954

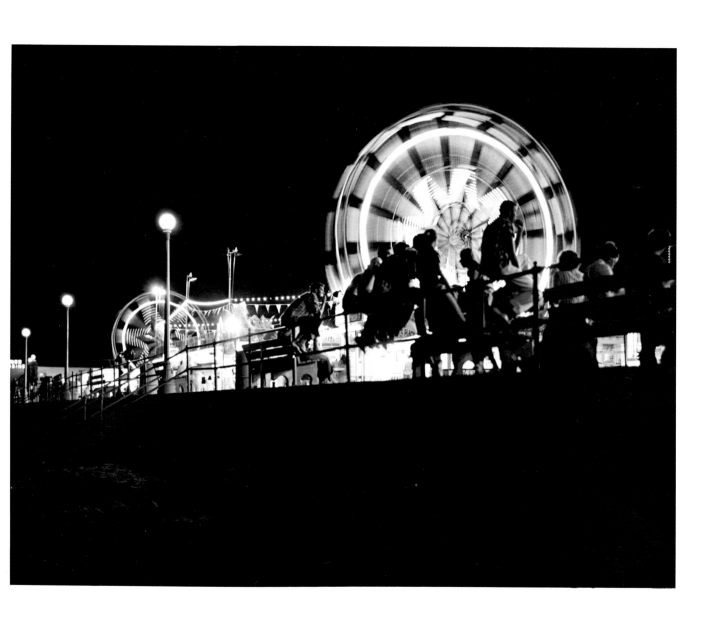

Prospect Harbor, Maine, c. 1966

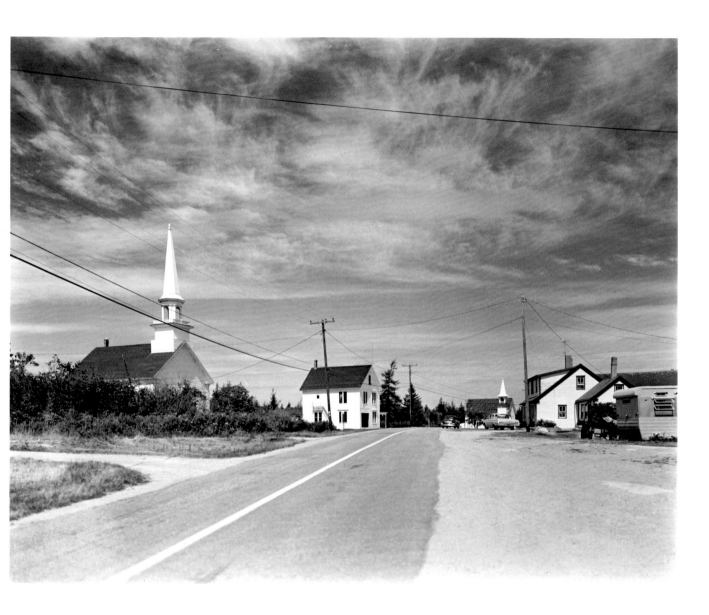

Melbourne Hotel, Melbourne, Florida, 1954

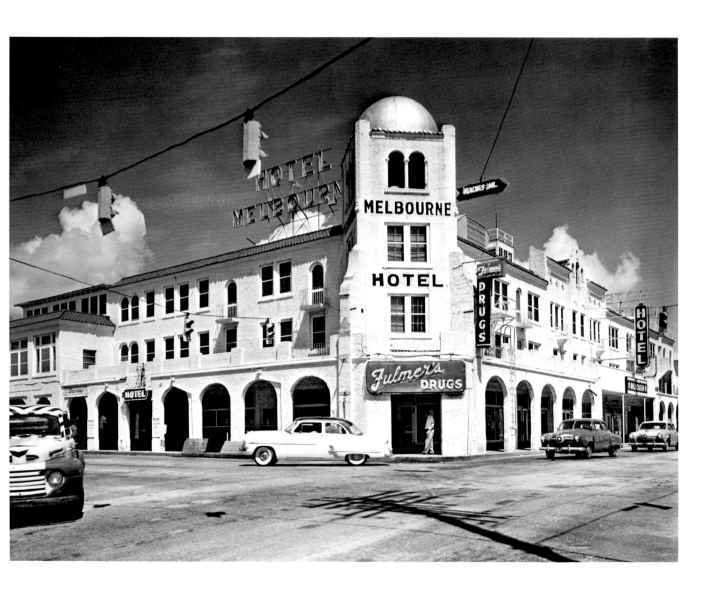

Houses, Newark, New Jersey, 1933

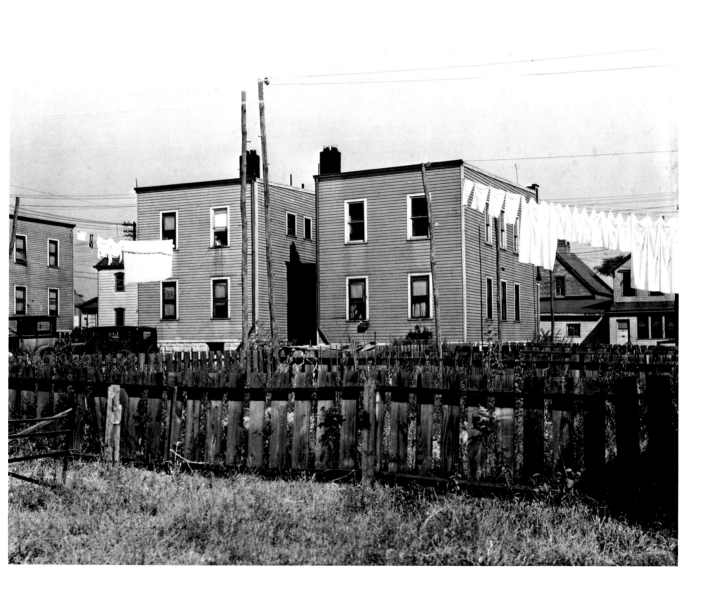

Bonaire Motel, Miami Beach, 1954

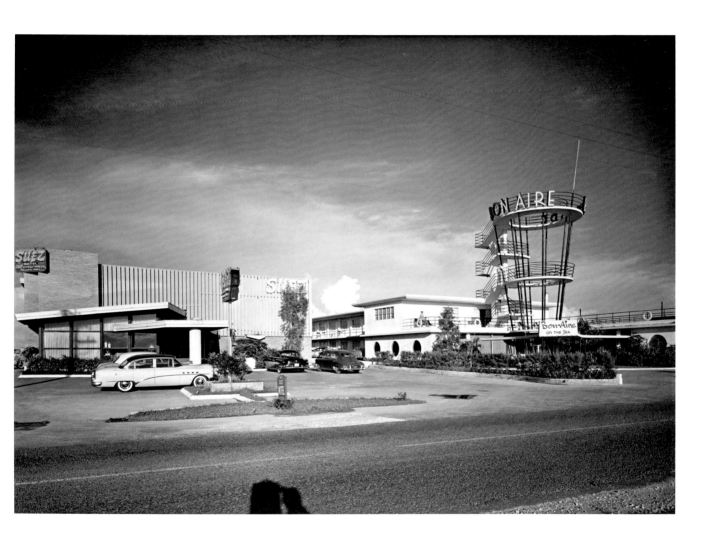

Boardwalk, Daytona Beach, Florida, June 23, 1954

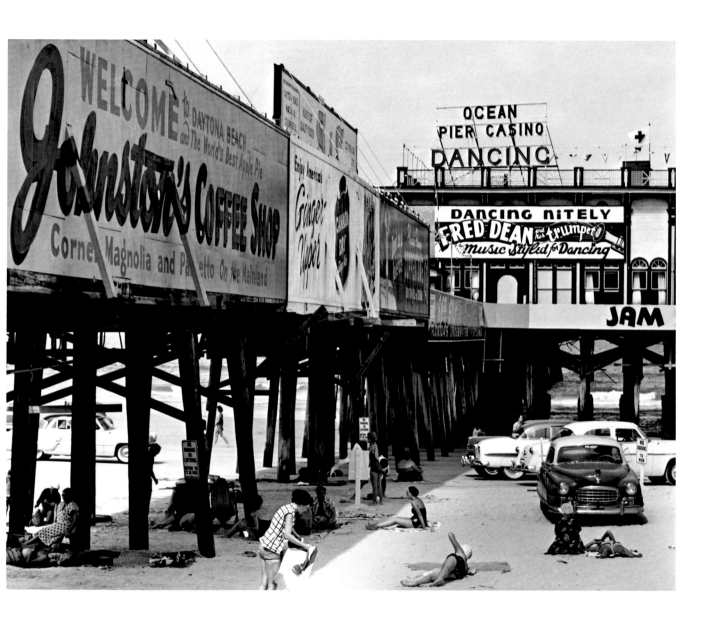

Edward Hopper, Greenwich Village, New York, 1947

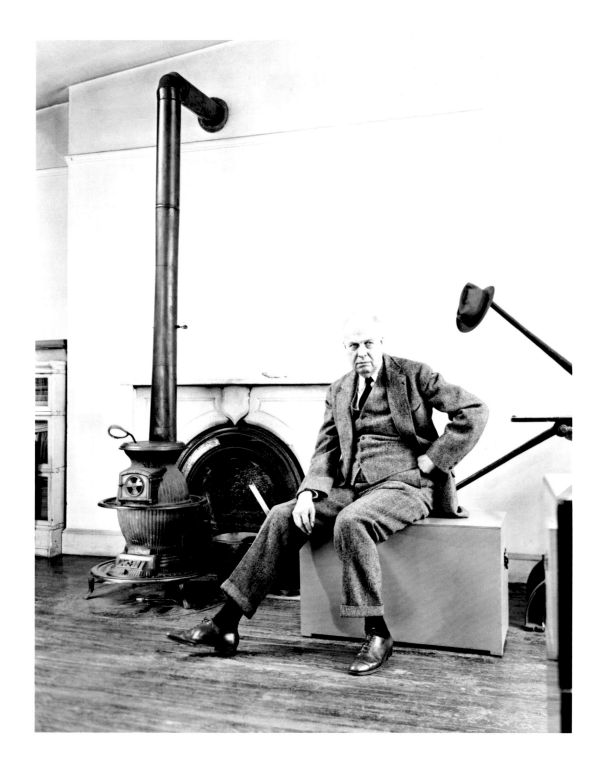

Milliken's general store on Sunday morning,
Bridgewater, Maine, August 22, 1954

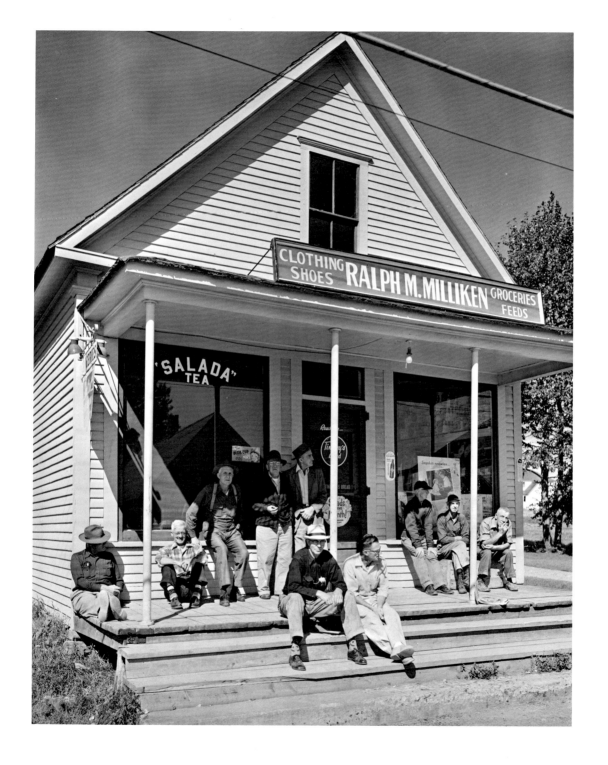

SELECTED INDIVIDUAL EXHIBITIONS

1926. Au Sacre du Printemps, Paris.

1930. Contemporary Art Club, Harvard University.

1934. New School for Social Research; Museum of the City of New York; Yale University.

1935. Smith College; Museum of Fine Arts, Springfield, Massachusetts.

1937. Museum of the City of New York; Yale University.

1938. Hudson D. Walker Gallery, New York City.

1939. Federal Art Gallery; Museum of Modern Art, New York City.

1941. Massachusetts Institute of Technology.

1947. Galerie l'Epoque, Paris.

1950. Akron Art Institute, Akron, Ohio.

1951. The Art Institute of Chicago.

1953. Caravan Gallery, New York City; San Francisco Museum of Modern Art.

1955. Currier Art Gallery, Manchester, New Hampshire.

1956. Toronto Art Museum.

1959. Massachusetts Institute of Technology, Faculty Club; New School for Social Research.

1960. Smithsonian Institution, exhibits Physical Sciences Study Committee photographs for touring exhibition.

1969. Smithsonian Institution.

1970. Museum of Modern Art, New York City.

1971. University of Maine, Augusta.

1972. Wellesley College.

1973. Witkin Gallery, New York City.

1975. Focus Gallery, San Francisco.

1976. Marlborough Gallery, New York City.

1977. Treat Gallery, Bates College, Lewiston, Maine.

1978. Sarah Lawrence College.

1979. Provincetown Fine Arts Workshop.

1980. "Changing New York," Galerie zur Stockeregg, Zurich.

1981. "The 20's and 30's," International Center of Photography, New York.

1982. Smithsonian Institution.

1985. "Vision of the Twentieth Century," Massachusetts Institute of Technology Museum.

1986. Ikona Gallery, Venice, Italy.

1987. "The Beauty of Physics," New York Academy of Sciences.

1988. Foto Fest, Heritage Plaza, Houston; Silver Image Gallery, Seattle, Washington; Heckscher Museum, Huntington, New York.

SELECTED COLLECTIONS

Albert and Vera List Visual Arts Center, MIT, Cambridge, Massachusetts
Allen Memorial Art Museum
Art Institute of Chicago
Bibliotheque Nationale, Paris
Chase Manhattan Bank, New York
Detroit Institute of Arts
Fogg Art Museum, Harvard University, Cambridge, Massachusetts
High Museum of Art, Atlanta
Indiana University Art Museum, Bloomington
International Museum of Photography/George Eastman House, Rochester, New York

Menil Foundation, Houston, Texas
Metropolitan Museum of Art, New York
Minneapolis Institute of Arts, Minnesota
Museum of the City of New York
Museum of Fine Arts, Boston
Museum of Fine Arts, Houston
Museum of Modern Art, New York
New York Public Library
San Francisco Museum of Modern Art
Wellesley College Museum, Wellesley, Massachusetts
Yale University Art Gallery, New Haven, Connecticut

BRIEF CHRONOLOGY

1898. Born July 17, Springfield, Ohio.

1917. Leaves home to attend Ohio State University with the goal of becoming a journalist.

1918. Moves to New York City. Interested in sculpture.

1921. Sails for France.

1923. Moves to Berlin, returning to Paris after less than a year. Once back in Paris, is hired by Man Ray to work as a darkroom assistant in his portrait business.

1925. Begins to make her own photographic portraits. Ends professional commitment to Man Ray and, establishes her own portraiture studio.

1926. Visits Eugène Atget's studio for the first time. Has her first exhibition at Au Sacre du Printemps, Paris.

1927. Atget agrees to allow Abbott to make his portrait. He dies shortly thereafter, and photographs are bequeathed to his friend André Calmettes.

1928. Purchases all of Atget's work from André Calmettes. Exhibits at the First Salon of Independent Photographers with Man Ray, André Kertész, Paul Outerbridge, and Philippe Nadar.

1929. Comes to New York for a brief visit and decides to remain. Establishes a portrait studio, planning to photograph the city in her spare time.

1935. Begins teaching photography at the New School for Social Research in New York City. Receives funding from the Federal Art Project, a part of the Works Progress Administration, enabling her to photograph on a full time basis, and begin her project "Changing New York."

1937. Atget's photographs exhibited at the Museum of Modern Art.

1938. Learns of Lewis Hine and attempts to help him gain recognition for his photographs.

1939. Resigns from the Federal Art Project. Decides that her next project will show the links between science and art and begins fundraising.

1940. Begins experimentation with wave form photographs.

1942. Invents Projection Supersight System.

1944. Takes position as photo editor at *Science Illustrated*.

1945. Resigns from her position at *Science Illustrated* under its new management.

1947. Founds House of Photography to market and patent her inventions.

1951. "It has to walk alone . . ." statement made at the Aspen Institute for Humanistic Studies in Colorado.

1954. Photographing expedition with Elizabeth McCausland along Route 1 between Maine and Florida.

1956. Purchases land in Blanchard, Maine.

1958. Retires from her position at the New School for Social Research. Joins Physical Science Study Committee (P.S.S.C.) of Educational Services, Inc. in Cambridge, Massachusetts. Photographs scientific principles in innovative ways, many the first photographs of certain phenomena.

1959. Voted one of the Top Ten Women Photographers in the United States by the Professional Photographers of America.

1960. The Smithsonian Institution takes on the circulation management of the PSSC photographs; most were Abbott's.

1962. Moves to her property in Maine.

1968. Atget collection is sold to the Museum of Modern Art.

1971. Awarded honorary doctorate from the University of Maine.

1973. Awarded honorary doctorate from Smith College.

1981. Received the Association of International Photo Art Dealers award for Outstanding Contribution to the Field of Photography.

1982. A movie about Abbott's work, directed by Erwin Leiser, is released.

1986. Awarded honorary degree from Ohio State University.

1987. Awarded The First International Erice Prize for Photography.

1988. Inducted into Order of Arts and Letters by the French Government.

SELECTED BIBLIOGRAPHY

Books by Berenice Abbott:

The Attractive Universe, text by E. G. Valens, Cleveland: World Publishing Company, 1969.

Photographs, New York: Horizon Press, 1970.

The Red River Photographs, text by Hank O'Neal, Provincetown, 1979.

Changing New York, text by Elizabeth McCausland, New York: E. P. Dutton and Company, 1939. Reprinted as *New York in the Thirties,* New York: Dover Publications, Inc, 1973.

Greenwich Village Today and Yesterday, text by Henry Wysham Lanier, New York: Harper and Brothers, 1949.

A Guide to Better Photography, New York: Crown Publishers, 1941.

Magnet, text by E. G. Valens, Cleveland: World Publishing Company, 1964.

Motion, text by E. G. Valens, Cleveland: World Publishing Company, 1965.

A New Guide to Better Photography, New York: Crown Publishers, 1953.

A Portrait of Maine, text by Chenoweth Hall, New York: The Macmillan Company, 1968.

The View Camera Made Simple, Chicago: Ziff–Davis, 1948.

The World of Atget, New York: Horizon Press, 1964.

Selected Articles by Berenice Abbott:

Abbott, Berenice. "Documenting the City," *The Complete Photographer,* 1942, No. 22. Reprinted in the *Encyclopedia of Photography,* 1963, vol. 7.

———. "Eugene Atget," *Creative Art,* September, 1929.

————. "Eugene Atget," *The Complete Photographer,* 1941, No. 6. Reprinted in the *Encyclopedia of Photography,* 1963, Vol. 2.

————. "My Favorite Picture," *Popular Photography,* February, 1940.

————. "My Ideas on Camera Design," *Popular Photography,* May, 1939.

————. "The Image of Science," *Art in America,* 1959, 47:4.

————. "It Has to Walk Alone," *Infinity,* 1951, Vol. 7, pp. 6–7, 11.

————. "Lisette Model," *Camera,* 1975, pp. 4, 21.

————. *Lisette Model,* photographs by Lisette Model, introduction by Berenice Abbott, Millerton: Aperture, 1979.

————. "Nadar: Master Portraitist," *The Complete Photographer,* 1943, No. 51.

————. "Photographer as Artist," *Art Front,* 1936, Vol. 16.

————. "Photography 1839–1937," *Art Front,* 1937, Vol. 17.

————. "Photography at the Crossroads," *Universal Photo Almanac,* 1951, pp. 42–47.

————. "View Cameras," *The Complete Photographer,* 1943, No. 53.

————. "What the Camera and I See," *ARTnews,* 1951, Vol. 50, p. 5.

————. "Photography and Science," written in New York, 1939.

Selected Articles about Berenice Abbott:

"Abbott's Non-Abstract Abstracts," *Infinity,* 1962, Vol. 11, p. 1.

Bell, Madeline. "Changing New York," *Springfield Sunday Union and Republican,* April 23, 1939.

"Berenice Abbott Photographs the Face of a Changing City," *Life,* January 13, 1938.

Berman, Avis. "The Pulse of Reality—Berenice Abbott." *Architectural Digest,* April, 1985, Vol. 42, p. 74.

————. "The Unflinching Eye of Berenice Abbott," *Art News,* January 1981, Vol. 80, pp. 86–93.

Deschin, Jacob. "Viewpoint: Award to Berenice Abbott," *Popular Photography,* December 1981, Vol. 88, p. 46.

Katz, Leslie George. "Berenice Abbott As a Pioneer," *Berenice Abbott,* Ikona Gallery Exhibition Catalogue, Venice, Italy, June, 1987.

Kramer, Hilton. "Vanished City Life by Berenice Abbott on View," *New York Times,* November 27, 1981, sec. 3, p. 1.

Larson, K. "Abbott and Atget," *New Yorker,* December 1981, Vol. 14, pp. 150–151.

Lifson, Ben. "The Woman who Rescued Atget's Work," *Saturday Review,* October 1981, pp. 30–31.

McCausland, Elizabeth. "The Photography of Berenice Abbott," *Trend,* March–April 1935, Vol. 3, p. 1.

————. "Berenice Abbott—Realist," *Photo Arts,* 1948, Vol. 2, p. 1.

Newman, Julia. "Berenice Abbott—Pioneer, Past and Present," *U.S. Camera,* February, 1960.

"Picture This Career," *Mademoiselle,* August, 1934.

Reilly, Rosa. "Berenice Abbott Records Changing New York," *Popular Photography,* Vol. 3, p. 3, September, 1938.

Starenko, M. "I to Eye—Self-Portrait: The Photographer's Persona 1840–1985" [M.O.M.A. exhibition review] *Afterimage,* January 1986, Vol. 13, p. 17.

Steiner, Ralph. "Berenice Abbott," *PM,* April 19, 1942.

Sundell, Michael G. "Berenice Abbott's Work in the Thirties," *Prospects: An Annual of American Cultural Studies 5,* 1980, pp. 269–292.

Zwingle, E. "A Life of Her Own," *American Photographer,* April 1986, Vol. 16, pp. 54–67.

House Belfast, Maine along Route 1, 1954

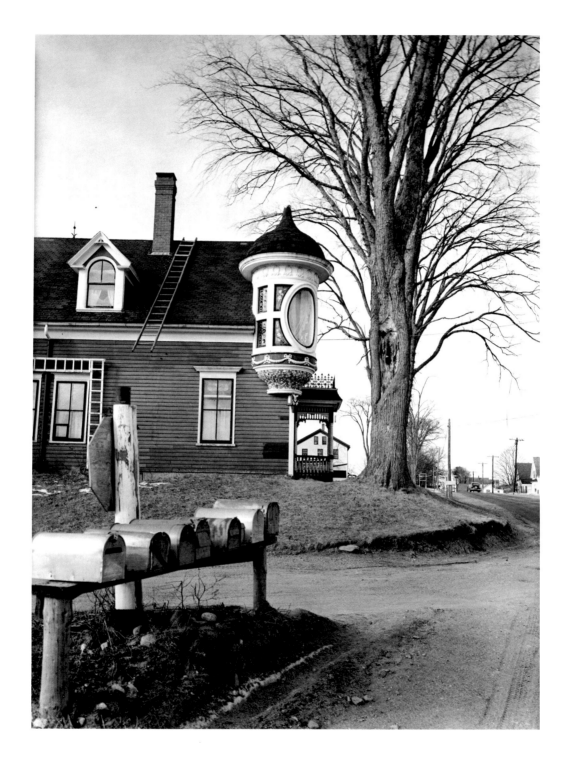

APERTURE Masters of Photography

The Aperture Masters of Photography series provides a comprehensive library of photographers who have shaped the medium in important ways.

Each volume presents a selection of the photographer's greatest images. 96 pages, 8 x 8 inches, 42 black-and-white photographs; hardcover, $12.50. The set of twelve titles, a $150 value, is available for $99.95 and can be purchased through fine bookstores.

If unavailable from your bookseller, contact Aperture, 20 East 23rd Street, New York, NY 10010. Toll Free: (800) 929-2323; Tel: (212) 598-4205; Fax: (212) 598-4015.

A complete catalog of Aperture books is available on request.

BERENICE ABBOTT

Essay by Julia Van Haaften

EUGENE ATGET

Essay by Ben Lifson

MANUEL ALVAREZ BRAVO

Essay by A. D. Coleman

HENRI CARTIER-BRESSON

Essay by Henri Cartier-Bresson

WALKER EVANS

Essay by Lloyd Fonvielle

ANDRE KERTESZ

Essay by Carole Kismaric

MAN RAY

Essay by Jed Perl

AUGUST SANDER

Essay by John von Hartz

ALFRED STIEGLITZ

Essay by Dorothy Norman

PAUL STRAND

Essay by Mark Haworth-Booth

WEEGEE

Essay by Allene Talmey

EDWARD WESTON

Essay by R. H. Cravens